a bOok Of LiFe

AKA "Things to think about when you're high"

the book

This is not a book for book lovers and I'm not a writer. These are just thoughts, poems and images that I find beautiful, interesting and ridiculous. Read it as some sort of art. Art in book form mixed with TRUTH.
There are messages in the messages.

Foreword

This book was a complete accident. I have a lot of trouble sleeping, I have a lot to worry about so I spend a lot of time thinking of solutions when I should be sleeping because I have work in the morning. I tried drinking, sleeping pills (OTC and prescription), Herbal tea, warm milk, meditation, counting sheep, counting steps, counting backwards and on and on.

After a 15 year hiatus from smoking pot a friend left some at my house after a weekend visit. I still had a bowl from my youth and I smoked it. I relaxed for the first time in 10 years. I slept like a baby and I woke up without hitting my snooze button a second time.

Before very long, smoking pot became a bedtime ritual a few nights a week and part of my ritual as I drifted off to dreamland was to write down thoughts on my cell phone note pad.

Eventually, I got around to opening my notes and read them sober. Some of them blew my own mind and I thought I should share this with someone. Other notes made no sense, I had clearly over indulged. Nevertheless, I decided to share many of these thoughts in this book, both the thoughts I considered profound as well as the ones I found laughable, juvenile and a little insane. Most of you won't <u>look</u> anyway.

The truth is, pot makes me kind of lazy and there was no way in hell I was going to make time to organize and fine tune a real book. Also, I'm not that smart, so I included quotes from people much more qualified than I to give you thoughts to ponder.

Whatever your methods may be, meditation, exercise, a glass of wine, a joint, you can pick a random page in this book and find an idea to consider while you are unwinding from the stress that the rat race has inflicted on you.

I don't expect anyone to agree with or appreciate all of the contents, but I'm sure you'll find something worthwhile in these pages, may be even the crap I'm embarrassed that I even thought of. This is a book of me.

I even included some of my poems and artwork.
USE ONLY AS DIRECTED and Try to enjoy :)

Dedicated to:
Aunt Olga
Sid
Alex
Mike Kelly
Brian Murray
Ryan Izon
Truth
Justice
Doing the right thing...

We are apart. Connected, but apart. The way which *we* regroup and choose our direction will determine our collective path from here.

It is now that the individual has the greatest outward influence on those around him. When we are thinking together, the individual has the most difficult time growing their ideas to those around them because there is no room to move. When the populations beliefs are the same, they are together in their beliefs, much the way atoms, closely packed, make the stone solid.

When the members of a society's beliefs are all varied and loose, that society is vulnerable to many potential individual beliefs because the individual is free to pass between other beliefs and individuals and grow his belief by giving it to them. That *can* be a good thing or a bad thing depending on who becomes the most influential.

Giving anything to anyone is a way to *make* yourself a part of them, the more people you give something to, a belief or philosophy, a simple idea , for example, the larger that idea grows.

When it comes to how a society thinks, collectively, at different times, we are solid, liquid or gas. Metaphorically speaking of course.

In a solid society, an idea (positive or negative) grows like cancer from a single point and that idea is met with much resistance from the whole, which, by nature, resists change, even change for the better.

In a liquid society, ideas spread like drops of ink in water. If there is not enough ink, the idea will be so diluted as to have little to no influence over the total volume of society. But enough ink, or a strong enough idea, will change society irreversibly.

In an air society, ideas are constantly bouncing off one another, twinkling as ideas grow to a few others and disperse only to meet other *individuals* and spread the idea to even more. In an air society, change is subtle, and difficult as information can not touch enough individuals to become relevant to the whole.

In a liquid society change happens more like an amoeba absorbs another and grows bigger. We are in a liquid society now, wars and elections, news events and fashion trends change our ideas and our thoughts quickly, like people being absorbed by the blob.

In a solid society, change isn't really possible, if we as a society are about to solidify, let's all agree to think responsibly. Let us collectively choose the best future society that we can, especially since we'll most likely be stuck in it for a while.

Birth is traumatizing.

I wonder if that is to prepare us for how hard life can be.

"It is the mark of an educated mind to be able to entertain a thought without accepting it."
— Aristotle

"We don't receive wisdom; we must discover it for ourselves after a journey that no one can take for us or spare us."
— Marcel Proust

"Science without religion is lame, religion without science is blind."
— Albert Einstein

"Science can purify religion from error and superstition. Religion can purify science from idolatry and false absolutes."
— Pope John Paul II

"I haven't reached nirvana yet, but I've been to Detroit."
— David Letterman

You are being tested. Every choice you make decides if you advance or not. You know *good* from bad, right from wrong. When you make the right choice, you advance.

Want to be enlightened? make the right choices to become enlightened. do not rely on rules or laws to help you make your choices. Often the right choice violates a rule or a law, each decision has its own reward or consequence, even if that reward or consequence only manifests as a feeling.

Some correct choices are more obvious than others. Don't steal, if there were no laws, no governments, only people, You would still know stealing from another person is the wrong answer. If you didn't know stealing was the wrong answer you wouldn't worry about being found out, make choices that do not lead to worry.

"Never let your sense of morals prevent you from doing what is right."
— **Isaac Asimov**

*"**A**ny fool can know. The point is to understand."*
— **Albert Einstein**

Words have power.

Thought is a virus.

A poem is a painting made from words.

"Trees are poems the earth writes upon the sky, We fell them down and turn them into paper, That we may record our emptiness."
— **Kahlil Gibran**

Thought **is** what happens before you choose. Some choices require more thought than others, Think responsibly and choose wisely.

"Make the most of the Indian hemp seed, and sow it everywhere!"
— *George Washington*

Nature's laws, man's laws and god's laws often conflict and contradict one another, when the human mind tries to abide by contradicting laws, the human mind goes insane. You know right from wrong, just do what is right in any situation.

Television as an organism.

Television as an organism (Use your imagination) is shaped not unlike a squid. The tips of it's long tentacles are made of friendly programing. They caress, they smile and they lull you into sedation.

There are parts evolved to be more intimidating, which appear to be prepared to consume you if you approach. There are parts evolved to lure you in like the small light on the Angler fish. Drawing you in, representing itself as potential sustenance only to consume the hungry victim. There are parts which are poison like the trailing tentacles of a jellyfish, many build up tolerances to these poisons.

the Internet is a branch on televisions evolutionary family tree, now a different breed but not unrecognizable next to it's ancestry. The roots of these organisms can be traced back to cave painting on through the renaissance. Mankind refined ever more ways to record and refine information. This information explains one persons experience to another person who has not actually had that particular experience. The downside is not all of the information is true. The goal is to <u>keep</u> evolving.

Books were the strongest branch of this organisms family history until recent times. Sound was recorded and played back... Photography was invented and the family tree began to bloom. It was not until these separate species were combined to create the hybrid we call television that the creature m**a**nkind tende**d** for all those aeons grew too large to control. Not only can man no longer control it, it has begun to control us. It is now alive.

Your theory is crazy, but it's not crazy enough to be true.

— **Niels Bohr**

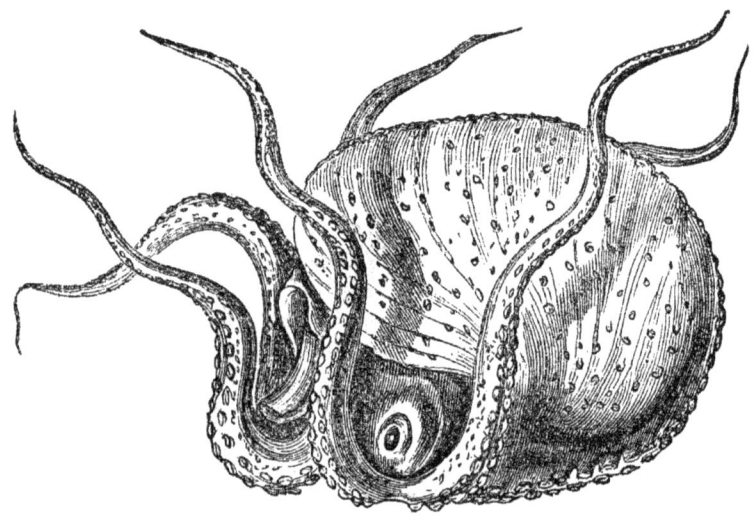

Science does not know its debt to imagination.

— **Ralph Waldo Emerson**

There are infinite numbers of universes (Should that say "Universi"? or "Univi"?). There is a universe in the shape of every thing that there is. Our universe could be shaped like a smoke ring at the growing end of a snail shell ever expanding from a tiny version of itself leaving it's past in the solidified death of time.

Just as every shell on the beach is it's own universe, so too is every grain of sand Every shape, every size, animate and inanimate. It is ALL living, in all directions, inward and outward.

Then again, our universe may be shaped like a donut....

I believe that Astronomers Looking ever outward and Subatomic particle physicists looking ever inward will eventually meet in the middle.

We are time. We are liquid.

"Sometimes, if you stand on The bottom rail of a bridge and lean over to watch the river slipping slowly away beneath you, you will suddenly know everything there is to be known."
— *A.A. Milne*

Here's a visual exercise for your mind's eye.

Visualize tim**e**, not just linearly, but as liquid, start by seeing time as a particle of liquid. A tiny point of tim**e**, singular, **a**lone. **S**uspended, perfectl**y** still, centered, floating in nothing.

Another point of time approaches, distant, constant. The points of time grow closer, drifting toward **o**ne another, until they meet.

The two points of time combine. A larger point of time now. Many points combi**n**e. Growing, liquid points, growing and falling, like rain.

like water, tim**e** combines, collects into pools until it spills over and flows.

Many pools combine and flow together, time is as a river. Flowing, twisting, swirling. Little whirlpools.... Looping. As the river of time reaches it's delta and prepares to meet the sea, the flow begins to disperse, it slows.

At times the flow even reverses, pushed back from the great volume of the tide of the sea. The river of time mingles with the sea of time.

They have never been separated, always a part of the other yet this delta is where they meet. Farther from the delta time slows, as it's depth increases. The deep is still.

In the ocean of time the surface is vast and active. Time splashes into droplets, suspended, separate, then rejoins itself. The tiniest droplets, independent pieces of time, so small that they float, rise above the ocean. Rising and twirling, joining one another and then separating again. A constant, chaotic dance consisting of a never-ending supply of individual entities so small and so free yet in numbers and distance even more vast than the ocean of time they left behind. Floating far above the ocean of time they left behind. The cycle repeats.

"The simple things are also the most extraordinary things, and only the wise can see them."
― *Paulo Coelho*

"I wish I could freeze this moment, right Here, right now and live in it forever."
― *Suzanne Collins (Catching Fire (The Hunger Games, #2))*

What many call God is our collective, conscious energy, you are connected to it.

You have a choice, many people are just parrots, animals whose brains possess the ability to hear sound understand some basic meaning and repeat it. Choose to understand more meaning, choose to think before you repeat.

"No one can make you feel inferior without your consent"
— Eleanor Roosevelt

Some emotions on faces leave permanent traces which years can not erase. Do not let your being exist without meaning, in a happy *or* a negative place.

Experience **the whole spectrum.**

"Knowledge speaks, but wisdom listens"
— Jimi Hendrix

There are times when I wish I could make you understand how painful it is for my spirit to be trapped in this body, in this life. My spiritual pain is constant and my emotional pain is unbearable. I am much more than anyone I've ever met has ever imagined, we all are. I want them to know. They will not allow me to show them and it hurts.

"Let no man pull you so low as to hate him."
— Martin Luther King Jr

Sometimes I feel like I am a vacuum, <u>nothing</u>, for all the misery of the world. The worlds pain is killing me.

"This is the way the world Ends Not with a bang but a whimper."
— T.S. Eliot

"Turn your wounds into wisdom."
— Oprah Winfrey

There is no such thing as "all" or "none." 5

Feel Good, Do Good, Be Good.

Real humanity cares for one another. Currently, based on what I see on our corporate sponsored news propaganda, there are apparently too many people on our planet to care. Lucky for me, my television can be unplugged.

"The best index to a person's character is how he treats people who can't do him any good, and how he treats people who can't fight back."
— **Abigail Van Buren**

"Whenever I hear anyone arguing for slavery, I feel a strong impulse to see it tried on him personally."
— **Abraham Lincoln**

"It is unwise to be too sure of one's own wisdom. It is healthy to be reminded that the strongest might weaken and the wisest might err."
— **Mahatma Gandhi**

"Having children makes you no more a parent than having a piano makes you a pianist."
— **Michael Levine**

and

Your spirit or your spirituality is not religion, religion is a label people made to attempt to describe our spirituality. Your spirit is your life force. What you consume strengthens or weakens your spirit just as what you consume strengthens or weakens your body and your mind.

Feed your spirit and you feed your life.

You have a choice as to what you feed your spirit.

The laws in America are increasingly killing your spirit by taking away your choice.

Many of these laws you must choose to ignore in order to feed your spirit.

"The saddest aspect of life right now is that science gathers knowledge faster than society gathers wisdom."
— Isaac Asimov

"Don't Gain The World & Lose Your Soul, Wisdom Is Better Than Silver Or Gold."
— Bob Marley

In society,

**You are only as good as your last memorable action,
that is, assuming people remember ...**

DON'T BE A GOKEY!

Just don't

"Wise? No, I simply learned to think."
— **Christopher Paolini**

"Learn from the mistakes of others. You can never live long enough to make them all yourself."
— **Groucho Marx**

"I'm not in this world to live up to your expectations and you're not in this world to live up to mine."
— **Bruce Lee**

"Insanity is Relative. (**add** ly)
It depends on who has who locked in what cage."
— *Ray Bradbury*

A good movie was a great story first, and at the core of any great story is a powerful message. Build on the message.

"He who knows all the answers has not been asked Every question."
— Confucius

When **you write, you ain't wrong.**

"Honesty is the first chapter of the book wisdom."
— Thomas Jefferson

All things creative are a form of masturbation by the creator.

Science arose from poetry... when times change the two can meet again on a higher level as friends.
— Johann Wolfgang von Goethe

"Those who believe in telekinetics, raise my hand."
— Kurt Vonnegut

Sex was the first religion.

Flowers are nature's orgasms. Women love flowers, when you give a woman flowers its like you are symbolically giving her

orgasms.

Religion is a thorn on a rose. It is the dangerous part of something beautiful. The thorns are Evil.

"We must live together as brothers or perish together as fools."
— *Martin Luther King Jr.*

"Mockingbirds don't do one thing but make music for us to enjoy. They don't eat up people's gardens, don't nest in corncribs, they don't do one thing but sing their hearts out for us. That's why it's a sin to kill a mockingbird."
— *Harper Lee*

"If Christ were here there is one thing he would not be —a Christian."
— *Mark Twain*

Jesus of Nazareth, as I understand, chose death. He Committed suicide by getting himself turned in full well knowing that was going to get him killed. And he chose to die. I view this act as the modern day method of "Death by Cop"

How many of us are choosing to die? Why do we look down on those who choose to die? Is looking down on a friend who killed himself much like looking down on Jesus?

"Only if he comes back" the cynic in me says. Then I think to myself "maybe I should kick the cynic out"

In my head, I can choose which voice to agree with. In this instance I disagree with the cynic.

There should be words in this space,
so I added them.

"The way out is through the door. Why is it that no one will use this method?"
— Confucius

Throughout life people will make you mad, disrespect you and treat you bad. Let God deal with the things they do, cause hate in your heart will consume you too.

— Will Smith

"I'm just trying to make a smudge on the collective unconscious."

— David Letterman

"Somewhere, something incredible is waiting to be known."

— Carl Sagan

At a point when I loved and respected you enough to care what your answers were, you lied to me.

Now I don't love or respect you enough to even ask you my questions.

Perhaps the problem with time travel is that time is what is moving and we are fixed in place.

We, our conscious, physical selves, may be like a needle on a record or more like an anchored boat in a whirlpool. the only moving we do is toward the center as we age. If time can be thought of as a liquid form (I know I used this "time/liquid" thing earlier in the book but it fascinates me and I keep coming back to it in my thoughts) we may have a tendency to to drift, calmly, at times waiting for the current of a whirlpool to pull us in.

Time still moves slowly in the outer orbits when we are young but as the revolutions become tighter, closer to the center, our time, or our perception of time, quickens. It's just an idea...

"They always say time changes things, but you actually have to change them yourself."
— **Andy Warhol**

"Time is what we want most, but what we use worst."
— **William Penn**

"Time is an illusion."
— **Albert Einstein**

Time can be sensed. Our 5 senses are real. But we have more senses than the 5 which we immediately recognize. Our nose smells, our skin feels our ears hear, our tongue tastes and our eyes see.

The eyes may be part of the problem when it comes to recognizing additional senses. We haven't seen a gland or an organ or a location in the brain that is responsible for sensing time. Yet, we sense time. And we sense it differently from one another, just as each of us has our own pain threshold.

"Time flies when you're having fun" or "that lecture took for ever" are examples of perception of time. Time seems to speed up or slow down depending on what's happening around us or rather what we think about what's going on around us.

Banging your hand when it's warm out doesn't seem nearly as painful as banging your hand when it's cold. That is an example of how a currently accepted sense has a spectrum similar to how our ears perceive volume. Loud music we love is tolerated, loud music or other noises at the same volume can literally feel painful. Our taste buds enjoy or can't tolerate spicy foods, rich foods etc...

You get the picture.

Time, as a sensed experience is different for each of us. Therefore time may be internal. There is a part of us which senses and possibly creates time or, visualizing time as a liquid form again, this sense of ours sends ripples into the time around us and the ripples adjust frequency in response to outside stimuli adjusting our sense of time, fast or slow. To reference the eyes in their simplest function, sensing light and dark.

So based on this idea, time is a sense-able stimuli and we have a sense to detect it. And time can be adjusted by being sped up or slowed down as we perceive it based on what we are thinking, hearing, smelling, tasting and seeing.

Time slows down when someone sees an accident in motion, so, time is affected by our other senses. Time and our perception of it does not go away when we lose a sense, like hearing, for example.

So while our senses all effect time, none of them are the soul receiver for time. The receiver is in us, it may be our entire entity. What the receiver is, is less important important than the fact that it exists within us.

"The future is something which everyone reaches at the rate of sixty minutes an hour, whatever he does, whoever he is."
— *C.S. Lewis*

Since time exists we should be able to discipline this sense. If we can speed up and slow down time as we perceive it, there must be a way to navigate it with intention, by choice. There is obviously more aspects to this sense than there is to the other senses. And, once exorcised and mastered <u>is</u> it possible to "swim" against the current of time?

Could there be some among us who have already mastered this ability? By navigating time do they experience different dimensions by choice? Would they choose to use this ability to become wealthy? Would they have any need for anything the majority consider normal needs? What would you choose to View?

With the ability to navigate time, would the perceived effects of time be navigable as well? Can we be tuned to a level where we can grow old or grow young at will? Just wondering, smoking pot has that effect as a matter of fact, I find pot to be the best way to alter my perception of time.

"How did it get so late so soon? It's night before it's afternoon. December is here before it's June. My goodness how the time has flewn. How did it get so late so soon?"
— Dr. Seuss

"If a thing loves, it is Infinite." **— William Blake**

"Time is a game played beautifully by children."
*— **Heraclitus***

*"I sit beside the fire and think
Of all that I have seen
Of meadow flowers and butterflies
In summers that have been*

*Of yellow leaves and gossamer
In autumns that there were
With morning mist and silver sun
And wind upon my hair*

*I sit beside the fire and think
Of how the world will be
When winter comes without a spring
That I shall ever see*

*For still there are so many things
That I have never seen
In every wood in every spring
There is a different green*

*I sit beside the fire and think
Of people long ago
And people that will see a world
That I shall never know*

*But all the while I sit and think
Of times there were before
I listen for returning feet
And voices at the door"*
*— **J.R.R. Tolkien***

I've always felt, to some degree, that there is no point wasting time with a lover who is not "the one" when "the one" may be inadvertently passed by while wasting that time with a distraction. Of course, I've hooked up with "the one" several times now...

"Yesterday is gone. Tomorrow has not yet come. We have only today. Let us begin."
*— **Mother Teresa***

"We are addicted to our thoughts. We cannot change anything if we cannot change our thinking."

— **Santosh Kalwar**

 Our phones keep track of us. Every moment of every day. Unless we leave them home. There is a record of where you go, who you go with and how long you were there.

 Social networking tracks what you were doing while you were where you were. Unless you don't say.

 Your mind records every moment of you living life.

 Someday your life may flash before your eyes, someday someone may replay every moment your mind ever recorded and what you were feeling as you lived it.

Will you be vindicated or condemned by your memory?

Choose wisely. ## Think responsibly.

"No brain at all, some of them [people], only grey fluff that's blown into their heads by mistake, and they don't Think."
— **A.A. Milne, The House at Pooh Corner**

In the time it takes a charge to connect a synapse, an entire universe is created. within that universe every outcome of every scenario is played from beginning to end and the receiving side of the synapse passes on the the outcome it prefers the most. Think responsibly. You are choosing which universe you exist in.

"I shall take the heart. For brains do not make one happy, and happiness is the best thing in the world."
— **L. Frank Baum**

I propose that every Atom has a "memory" of every form it has ever shared with other atoms. And that each atom has a complete "memory" not only of its own position in said form but also a "memory" of its "neighbors" and of course, each neighbor has a memory of its neighbors and therefore, theoretically, one could recreate anything by simply learning how to read an Atom's memory.

I don't know anything. I am not you.

Ladies, at night, when you're going to sleep and you're annoyed because he's going to sleep with his back to you instead of holding you like he used to do. Consider that maybe he would like being held too.

"That's what real love amounts to - letting a person be what he really is. Most people love you for who you pretend to be. To keep their love, you keep pretending - performing. You get to love your pretence. It's true, we're locked in an image, an act - and the sad thing is, people get so used to their image, they grow attached to their masks. They love their chains. They forget all about who they really are. And if you try to remind them, they hate you for it, they feel like you're trying to steal their most precious possession."
— *Jim Morrison*

Although I can't fully remember. I suspect that as a baby I Only received help when I cried, and sometimes only when I cried even harder. Meaning my mother must not have been very intuitive, or maybe she kept me in a crib rather than hold me. I suspect that babies of mothers who are intuitive or hold them almost constantly and know what to do before that baby resorts to crying will grow up happier. Babies who feel alone and afraid more than they feel loved and safe will keep those feelings their entire life. At least I did....

No matter how bad your life gets, you are going to wake up to your real life when it is all over. Anything is better than nothing.

They destroyed my wonder. They hid my magic. They stole my innocence.

The enlightenment is under threat. So is reason. So is truth. So is science, especially in the schools of America.
— Richard Dawkins

Nothing has to be anything.

Watching the crowd at the fair today I found myself disgusted and embarrassed at what the American public have become. Society no longer consists of mostly good and morally conscious people with a few bad eggs. I believe we are now the opposite of what decent society should consist of. Everyone can't be a rebel. That's stupid. I blame Hollywood. I blame Liars. The irony in my observation is that in the ideal rockwellian society that I would prefer to live in, I would no doubt rebel against the conformity and lack of free expression that I long to be surrounded by.

I often suspect I am actually in hell.

"The mind is its own place, and in itself can make a heaven of hell, a hell of heaven.."
— ***John Milton*** *(Paradise Lost)*

Welfare is the foundation for slavery. When anyone is dependent on anything they are as good as owned by that dependence.

"War is peace.
Freedom is slavery.
Ignorance is strength."
— George Orwell (1984)

My potential grows less with each passing day. The sins of my past hold my present at bay.

Are there three words which make a meaningful sentence in whatever order they're presented?

_____ _____ _____

Light allows us to see Everything within reach, but darkness allows us to see the things beyond our reach. The distant light, The things to strive for, like the stars at night.

Homophobia is so gay.

Please God, Help me.

"Patience and wisdom walk hand in hand, like two one-armed lovers."
— **Jarod Kintz**

"The angel looks down and says "Oh dear boy, can't you show me nothing but surrender?"
— **Patti Smith**

Is that all you See?

Sometimes looking into the clear night sky out into infinity I get the same nervous feeling as when I was a small child looking down the basement stairs into the darkness.

"Three things in human life are important: the first is to be kind; the Second is to be kind; and the third is to be kind."
— **Henry James**

"Wonder is the beginning of wisdom."
— **Socrates**

*"A little nonsense now and then,
Is cherished by the wisest men."*
— **John August**
(Not Willy Fuckin' Wonka?)

Making fun of cripples is lame.

The nice thing about having lots of money is you can do anything you want anytime you want. But some people just shouldn't have that kind of money.

"Anyone who lives within their means suffers from a lack of imagination."
— **Oscar Wilde**

"Too many people spend money they earned..to buy things they don't want..to impress people that they don't like."
— **Will Rogers**

Remember to forget the bullshit.
In the future, we won't have that problem.

fuck

shit

piss

That was for Todd. Hey, it's my damn book, don't like it? Write your own book.

"the best 4 letter word in the world is Hope"
*— **Stephenie Meyer***

"The planet is fine. The people are fucked."
*— **George Carlin***

After careful thought, I've come to the conclusion that earth may very well be some sort of planetary insane asylum and there may be no point trying to make the inhabitants here understand my moments of clarity.

The distance between insanity and genius is measured only by success.
— Bruce Feirstein

Money, or anything of perceived value is necessary to motivate the advancement of civilization. It helps to speed progress, though not always for the better. There must be inequity in the access to the wealth to encourage those without wealth to work harder to attain more.

The system must be set up in way that allows that wealth to be attainable by anyone but not by all. Once the system is off balance to a point where the few with the most wealth choose to hoard the wealth for the acquisition of power, the system has failed.

Wealth must actually be attainable by the population and not dangled like a carrot before a mule in order for the system to work correctly.

It's too bad everyone won't just keep doing what they do without money as a motivator. Money is the one thing everyone seems to worry about. Eliminate money and we eliminate worry. When your car breaks down you don't worry about if it can be fixed. Anything can be fixed. You worry about how much it will cost.

When the momentum of an idea reaches the speed at which the idea explodes, People get rich. Invest in the next explosion before it explodes. At the moment you are reading this, it's still just an idea.

"I never made one of My discoveries through the process of rational thinking"
— **Albert Einstein**

This world has wasted my talents as a creator and an artist. All my time and efforts are drained by simply trying to survive. I am cursed to live in a society with no respect for the ability to create.

"Creativity is intelligence having fun."
— **Albert Einstein**

"The painter has the Universe in his mind and hands."
— **Leonardo da Vinci**

When a shooting or a bombing or any tragedy is perpetrated by an individual it is not just an incident where some lunatic asshole reached his breaking point. It was the end result of how someone responded to how they were treated over the course of their life on this earth, in this county, in the town that he lived, in the schools he attended, his employers, his peers, his family.

This horrible decision to kill was the choice of a 2 year old child, left alone to cry instead of being comforted. It was the choice of a 7 year old told to "walk it off" after an injury on the soccer field, the 9 year old who came home with exciting news only to be told to sit down and be quiet too many times. The 12 year old standing alone embarrassed and frightened as their peers laugh at them and no one steps up, stands by them and assures them "don't worry, it's not as bad as it seems". This is the teen with the zits, literally uncomfortable in their own skin dying on the inside for a friend, a girlfriend, a boyfriend.

No one is born with this destiny in their future.. And no one should ever consider taking innocent lives to express their rage, at that point they are beyond comfort or reassurance that they are not alone or that everything will be ok, Once they make that choice, they have truly become evil.

This evil was created by your apathy, your unwillingness to comfort or protect that child. Society is only as good as it's inhabitants treat one another. What have you <u>done</u> to each other?

Science may have found a cure for most evils; but it has found no remedy for the worst of them all - the apathy of human beings.
— Helen Keller

"What is hell? I maintain that it is the suffering of being unable to love."
— Fyodor Dostoyevsky

Touch a scientist and you touch a child.
— Ray Bradbury
(Let's assume he means shaking hands)

"Suffering is a gift. In it is hidden mercy."
— Rumi

Choose your own destiny

Close your eyes and try this after you've read it, smoke a little weed if you can't make yourself relax or if you don't know how to meditate. Picture yourself as a point in empty space, a point created by the intersection of three lines of light. Three lines of strings of light in perfectly straight lines, intersecting at perfect 90 degree angles. Straight up and down, crossed with a perfectly level, horizontal line and intersected at the same point a third line straight forward and backwards. You are that point where the lines intersect. You move through space using these lines. Forward, backwards, left, right and up, down.

Now add more lines, many of them, perfectly distanced from one another in all directions and still all lines intersecting at a single point of light which is you and use them to fly.

Now add so many lines you can not tell one line from another.

You glow from a point in the center, you make your own light and it reaches in all directions and never ends.

How close to infinity you get is dependent on how brightly you glow.

There is a single light of science, and to brighten it anywhere is to brighten it everywhere.
— *Isaac Asimov*

In order to see the good in others, we must first be good, through being good and seeing the good in others we may tip the balance toward a better world.

We will learn to identify the better person when choosing a leader. We must choose to promote and elect the best man rather than the best actor, lier or manipulator in all aspects of life, all ages, relationships and social interaction.

We must learn to reward those who are just and right and intelligent and punish those who intimidate, lie and steal.

"Great minds discuss ideas. Average minds discuss events. Small minds discuss people."
— Eleanor Roosevelt

Why was I so terrified as a child? Of the dark, being alone?

"I would rather walk with a friend in the dark, than alone in the light."
— **Helen Keller**

"We live as we dream--alone...."
— **Joseph Conrad**
(Heart of Darkness)

I feel more than most who know me realize I do. Yet my ability to express what I feel is handicapped. I try to express my feelings through art and writing so others will know I have feelings. Unfortunately, the world I live in seems to punish feelings by not allowing time for them. I have no time to feel because I have no time to create.

"A creative man is motivated by the desire to achieve, not only by the desire to beat others."
— **Ayn Rand**

If thought waves exist as actual, detectable energy then the wavelengths can vary. So, each of us thinks, feels at different levels of intelligence and thought levels, what we think, when we think and how we think.

You are now thinking about thought.

When one is intoxicated they are thinking at a different level or wavelength than when they are sober.

Now picture, if you will, that other entities operate at different "thought wavelengths" so, Only those with similar thought wavelengths are aware of one another.

Perhaps those who hallucinate could be operating on a frequency between two dimensions but unable to make sense of this overlap of frequencies which can confuse the brain making the person feel and look, for lack of a better term, crazy.

There is a similar, mid frequency zone one enters when they are high. Between overlapping frequencies, or wavelengths. Where hallucinations also often occur.

I propose that with practice we can "tune" our frequency of thought to whichever station we like. If you are not happy with

where you're life is, change your frequency.

I think we may be <u>evolving</u> mentally independent of our physical evolution. Although the two entities can influence each other, they are separate and equally real.

I also believe marijuana was a strong influence to the human evolution of thought and that even now it is a part of our physical, spiritual and thinking selfs. It is a tool we evolved with which helps us to learn, to adjust our thought frequency.

Without this adjustment our thought will become stagnant and whither.

If an elderly but distinguished scientist says that something is possible, he is almost certainly right; but if he says that it is impossible, he is very probably wrong.
*— **Arthur C. Clarke***

Science, my lad, is made up of mistakes, but they are mistakes which it is useful to make, because they lead little by little to the truth.
*— **Jules Verne***

What if you think of the words "here" and "now" as opposites?

What if you think of "fear" and faith" as connected to one another?

"Once you have tasted flight, you will forever walk the earth with your eyes turned skyward, for there you have been, and there you will always long to Return."
— **Leonardo da Vinci**

To be perfectly honest with you, I'm a liar sometimes and every word I have written on these pages is one hundred percent true for the most part. he He

"Be yourself; everyone else is already taken."
— **Oscar Wilde**

(Was that really a typo?)

Just because something is not obvious to you, doesn't mean it's difficult. It may be simple, once you understand.

When you're high, you're high.....

I never want to be addicted to drugs. I have a fear that if my conscious mind continues after life it would crave to feed that addiction with no physical way to get high.

On the other hand, maybe the next life is like being high without the consequences. Perhaps that is what drives the addiction. An age old desire to get back to the other side.

"If we find ourselves with a desire that nothing in this world can satisfy, the most probable explanation is that we were made for another world."
— *C.S. Lewis* (I've always felt this way)

I feel the other side pulling. I paused myself for too long. I remained while my world moved on, they insist I come along.

I would detach from them if I could. I would stay and you know that I would. But when I let go, the tension will throw me like an arrow from a bow.

I may not want to be there, the future, unknown. And I'm quite sure I can never come back. I'm frozen, I don't care if I do or I don't dare. If I don't I won't have to come back.

"Love is an irresistible desire to be irresistibly desired."
— Robert Frost

"I shall take the heart. For brains do not make one happy, and happiness is the best thing in the world."
— L. Frank Baum

GOD

What a puzzle, this thing called God
Invisible, infinite, ancient and odd

Relax, recall, make an effort to feel
Look inside, you will find the answers revealed

There is nothing so strong, so pure and so safe
As the knowing of truth when one finally wakes

There is no structure, standing today
Containing the knowledge to show you the way

No book on this globe, will explain the truth better
Than the mind's many pages, read letter by letter

The past has seen men with unbounded knowing
Directing our world from the wrong way it's going

Not many have listened, far less, understood
That all they were saying, was simply, be good

Try and you'll find, it was well worth the trip
Look for yourself, be brave, take a sip

Try and give up, you still change where you're going
Follow through, just for you, there's an ocean of knowing

There is something called God, I tell you it's true
The puzzle's completion resides inside you

"Space is big. You just won't believe how vastly, hugely, mind-bogglingly big it is. I mean, you may think it's a long way down the road to the chemist's, but that's just peanuts to space."
— **Douglas Adams**, The Hitchhiker's Guide to the Galaxy

"Without music to decorate it, time is just a bunch of boring production deadlines or dates by which bills must be paid."
— **Frank Zappa**

"A dream is just a dream. A goal is a dream with a plan and a deadline."
— **Harvey MacKay**

Think about what temperature feels like. Think about cold. It feels blue. Now think about hot. It feels red. You have just thought about what temperature looks like even though you can't see it without thinking about it. Now think about how amazing it is that we can think that way.

 Your body is not your soul. Your mind is not your soul. Your soul is who you really are. Your soul is who you are with or without your mind or your body.

Don't lie. Don't lie to others and don't lie to yourself. Be who you are. You are not your mind and you are not your body.

"Your conscience is the measure of the honesty of your selfishness. Listen to it carefully."
― **Richard Bach (Illusions)**

"Perhaps the logical conclusion of everyone looking the same is everyone thinking the same."
― **Scott Westerfeld**

It's Yesterday tonight and I am staring at the horizon
The lights in the sky are brighter than the most complicated people
 Sometimes I feel forever but it never seems to last
The delta of a river between the now and past
 Here and then it's gone as nothing ever stays
A second hand on a broken watch drifting through the days
 The end is coming down to who will get the most out of nothing
Remove yourself from your icy shelf, stop yourself from rushing
 The sleepers walking blindly look everywhere but in
to lose they choose to win by any means and it's a sin
 Lost within their genuinely false complex simplicity
It gets so lonely being crowded by the void of mass stupidity
 Knowing so few know about the limits of eternity
Nothing is secure and I'm alone with all of you to see.

Civilization now gone wild, our planet will not reconcile
Sign and file, choke on bile none of this can be worthwhile

The present hewn from time gone by, expedient economic tries
In future days the the forgotten ways remembered now as lies

The rulers erect with inequity and no real ideology
now force us toward the starting point with every fucking war decree

It seems to me our time denotes our world is now a sinking boat
The gold you hold will never float with popping rivets, rusting bolts

The things I'm learning ,old and new, I'm overwhelmed with Deja Vu
I knew you construe a poisonous brew and like a fool I had some too

This has all happened long before and somehow now it seems I saw
Greed, it picks and gnaws you raw it eats at you with teeth and claws

I watch as it unfolds again but can't seem to remember when
The breaking bough began to bend and now it's gone too far to mend

You all believed a thin veneer and now it simply won't adhere
The truth will conquer fear, my dear. It nears, another broken gear

No more living at this level, upside down and oddly beveled
You fit right in to be a rebel, now prepare to meet your devil

You can take anything anyway you choose. I've been told I should have my head examined, Hey, Einstein's brain is in a jar somewhere....
Being examined.

I'm only still here on this earth because I am a coward, I'm here because I am afraid to die. I don't want to live this life as it is any longer, but I am afraid to die. And I think this feeling may be killing me. I suspect this world is designed to make me want to die.

I feel so old and so tired.

"It takes a very long time to become young."
— *Pablo Picasso*

"Whenever you find yourself on the side of the majority, it is time to pause and reflect."
— *Mark Twain*

"Knowing yourself is the beginning of all wisdom."
— *Aristotle*

Music changes lives, Stop writing dumb ass lyrics.

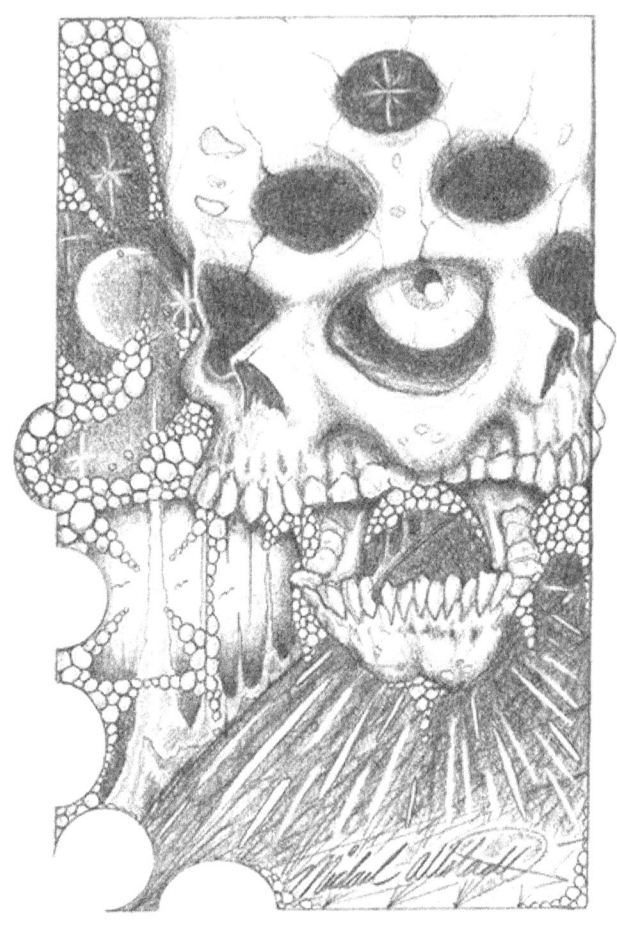

What happens if you get scared half to death twice?

— **Steven Wright**

Listen to some Pink Floyd, Listen to some Muddy Waters

However I die, I hope that I am enlightened enough at that time to experience death without fear, just acceptance. So that death is just another experience in this experience. — **Mike Allstadt**

"As a well spent day brings happy sleep, so life well used brings happy death."
— **Leonardo da Vinci**

"Death is no more than passing from one room into another. But there's a difference for me, you know. Because in that other room I shall be able to see."
— **Helen Keller**

Thought is a Virus

Making fun of the handicapped is lame.

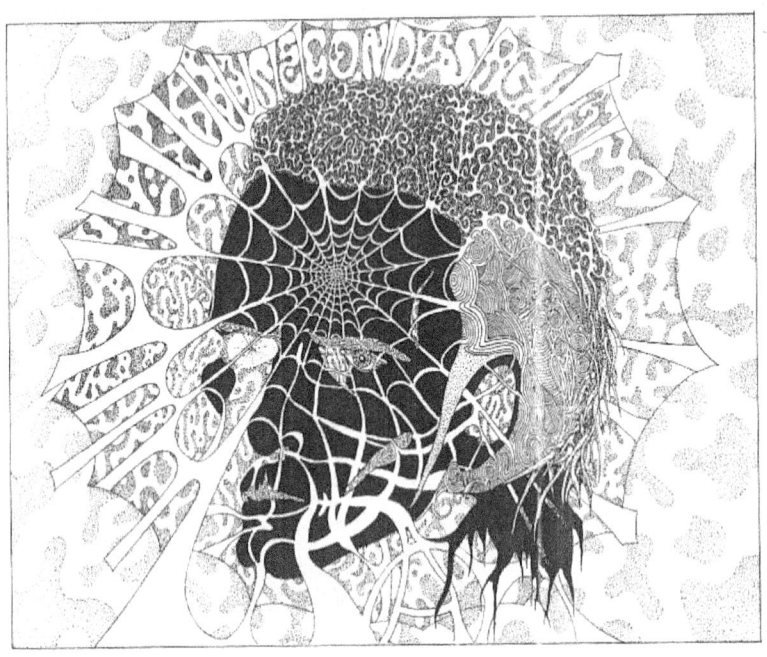

"The fool doth think he is wise, but the wise man knows himself to be a fool."
— **William Shakespeare**

"The only true wisdom is in knowing you know nothing."
— **Socrates**

When enough people believe. It will be.

Listen to what is being said, not how it is being said. There is a message in EVERYTHING and EVERYTHING is speaking in it's own way, it's own language, even when the sound is silent.

Isolation Reveals Self

"Penalties against possession of a drug should not be more damaging to an individual than the use of the drug itself; and where they are, they should be changed. Nowhere is this more clear than in the laws against possession of marijuana in private for personal use... Therefore, I support legislation amending Federal law to eliminate all Federal criminal penalties for the possession of up to one ounce [28g] of marijuana."
— *Jimmy Carter*

"The illegality of cannabis is outrageous, an impediment to full utilization of a drug which helps produce the serenity and insight, sensitivity and fellowship so desperately needed in this increasingly mad and dangerous world."
— *Carl Sagan*

Addictive narcotics destroyed the good that was the 1960's

Hope is the pillar
that holds up the world
Hope is the dream of a waking man
— Pliny the Elder

Hey Government! Quit trying to take away our hope!!!

No really, Don't be a Gokey.

"Only after disaster can we be resurrected. It's only after you've lost everything that you're free to do anything. Nothing is static, everything is Evolving, everything is falling apart."
— Chuck Palahniuk (Fight Club)

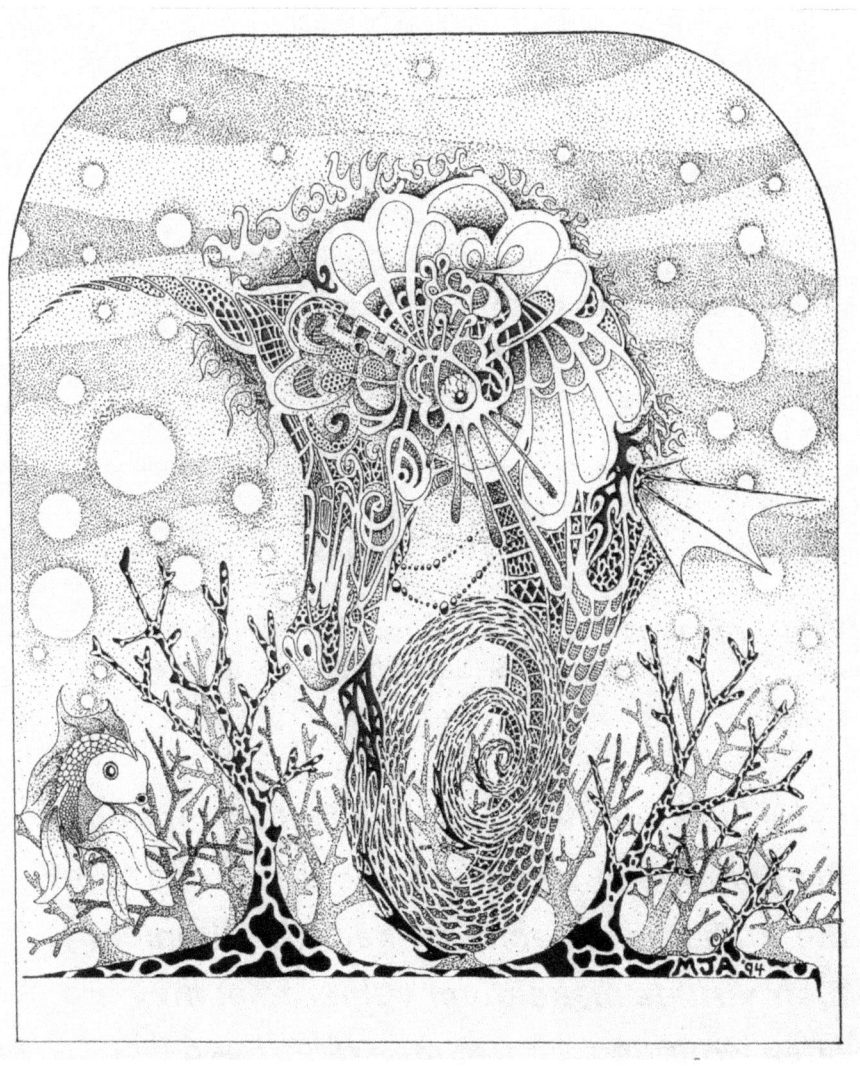

"What is most thought-provoking in these thought-provoking times, is that we are still not thinking." – **Martin Heidegger**

"Some of my finest hours have been spent on my back veranda, smoking hemp and observing as far as my eye can see."
— Thomas Jefferson

The Cannabis plant has a long history of use as medicine, with historical evidence dating back to 2737 BCE.

"Disbelief in magic can force a poor soul into believing in government and business."
— **Tom Robbins**

"Someday we shall all be one, Why fight yourself?"
— **Beastie Boys (Something's got to give)**

"The best people possess a feeling for beauty, the courage to take risks, the discipline to tell the truth, the capacity for sacrifice. Ironically, their virtues make them vulnerable; they are often wounded, sometimes destroyed."

— Ernest Hemingway

"I am one of you."

"Perfect paranoia is perfect awareness."
— **Stephen King**

"Anarchism, then, really stands for the liberation of the human mind from the dominion of religion; the liberation of the human body from the dominion of property; liberation from the shackles and restraint of government."
— **Emma Goldman**

Therefore all things whatsoever ye would that men should do to you, do ye even so to them
— **Jesus the Christ**

"When the people fear the government there is tyranny, when the government fears the people there is liberty."
— **Thomas Jefferson**

"paranoia is just a heightened sense of awareness"
— **John Lennon**

"Expose yourself to your deepest fear; after that, fear has no power, and the fear of freedom shrinks and vanishes. You are **free**."
— **Jim Morrison**

"If you can't say "Fuck" you can't say, "Fuck the government."
— **Lenny Bruce**

If you could hear my book I would end it with a song

Grateful Dead - Ripple - Lyrics
Robert Hunter wrote this song in 1970

If my words did glow with the gold of sunshine
And my tunes were played on the harp unstrung,
Would you hear my voice come thru the music,
Would you hold it near as it were your own?

It's a hand-me-down, the thoughts are broken,
Perhaps they're better left unsung.
I don't know, don't really care
Let there be songs to fill the air.

Ripple in still water,
When there is no pebble tossed,
Nor wind to blow.

Reach out your hand if your cup be empty,
If your cup is full may it be again,
Let it be known there is a fountain,
That was not made by the hands of men.

There is a road, no simple highway,
Between the dawn and the dark of night,
And if you go no one may follow,
That path is for your steps alone.

Ripple in still water,
When there is no pebble tossed,
Nor wind to blow.

You who choose to lead must follow
But if you fall you fall alone,
If you should stand then who's to guide you?
If I knew the way I would take you home.

69

*"If you've made your own hell,
then only you have the power to escape it."*
— Willie Nelson

Thank you to all, living and dead, above and below, who, without the influence of your words and messages, My words would make even less sense.

"Well if you want a friend, feed any animal."
— **Jane's Addiction**

"If you look in my heart you'd know it
I'm just trying to make my world better
If you look in my heart you'd see it
I got to do it alone"
— **Suicidal Tendencies**

Some say the end is near.
Some say we'll see armageddon soon.
I certainly hope we will cuz
I sure could use a vacation from this
Silly shit, stupid shit
— **TOOL**

"Feels Like the End of the World"
— **Firewater**

"We look hard to see for real
Such things I hear, they don't make sense
I don't see much evidence I don't feel."
— **Sisters of Mercy**

"I've been wading in the velvet sea"
— **Phish**

"They fill the children full of hate to fight an old man's war, and die upon the road to peace."
— **Tom Waits**

It is now time to allow our collective, conscious, spiritual self to catch up to our empty, technological self before they are separated forever.

Now

that you have read the book in it's entirety (and I assure you, not many have) I must tell you that there are codes hidden in these pages.

If you Can decode the true message, you will know the secret of life. I can't tell you what it is.

Only show others the first steps.
The steps they climb beyond that is for them to decode.

It's worth it.

Read it backwards,
then forward again.
Look inside and outside.

There is more to see.

"If the universe is all that there is and we know that the universe is constantly expanding, then what is it expanding into?"
— **Art Bell**

<u>The universe is breathing</u>

Keep your promises to others and to yourself, do what you say you will do.

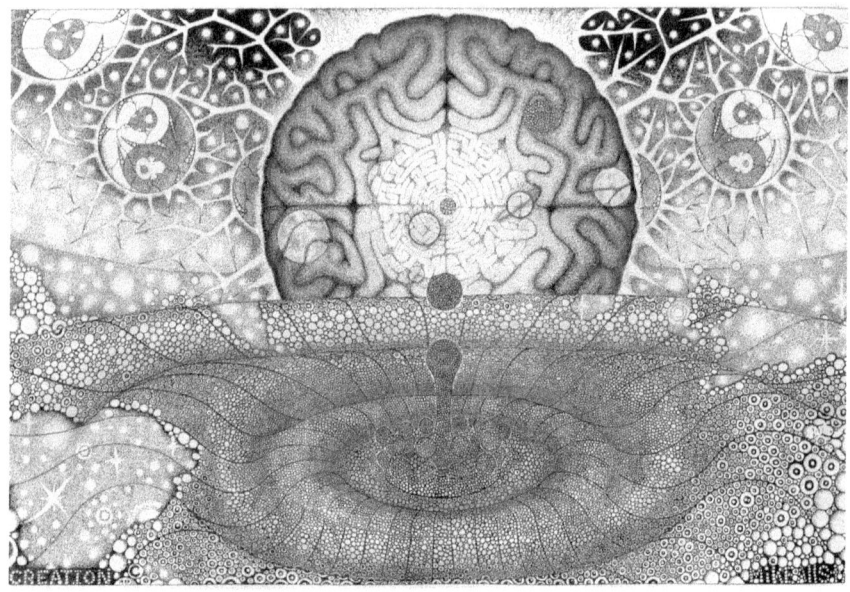

"In a time of destruction, create something."
— **Maxine Hong Kingston**

no part of any original content (other than publically available quotes by others) may be otherwise or subsequently reproduced, downloaded, disseminated, or transferred, in any form or by any means, except with prior written agreement of, and with express attribution to the author. Spend some time with a beggar, Talk to them, beg with them. Understand how they came to be where they are. When your time with them is complete, Thank them for allowing you to beg with them, give them what was given to you in the time that you spent begging by their side. Understand that we have created laws against helping each other. By removing beggars from the sidewalks of our cities we are taking away the privilege of helping another human being who is less fortunate than our self. Many of the laws that we enact are, in fact, a crime. Think about that.

Don't judge books by covers

www.ingramcontent.com/pod-product-compliance
Lightning Source LLC
Chambersburg PA
CBHW071622170526
45166CB00003B/1153